Us

Curtis Wiklund

Andrews McMeel
PUBLISHING®

$\mathcal{U}s$

\mathcal{J}t was March, and my wife, Jordin, was doing a 365-day project where she was taking a photo every day for a year. She asked if I would join her with a new drawing every day. I used to draw a lot as a kid, and I had always made her hand-drawn holiday cards.

For 365 days (and then some), I drew something, anything, every single day. Most of the time I would do it at night and show her in the morning, like a letter for her to wake up to each morning. Many of the drawings ended up being of the two of us, just living our normal life together.

When the year was complete, I compiled all the drawings of Jordin and me together as a Valentine's Day gift to her and then shared them on my website. It was a surprise, even to me, how many drawings of us there were. That collection of images was shared and re-shared many thousands of times, both by individuals and news outlets, from TODAY.com to ABC and *The Huffington Post*. Celebrities like Ashton Kutcher, Lil Wayne, Kathie Lee Gifford, and George Takei also began sharing the sketches as a testament to love. The captions have been translated widely, and the images shared around the globe. At one point, the images were ranked by Imgur.com as, worldwide, the most viral images on the Internet. The most exciting part for me, is that they have been published and made into this very book that you are holding—a book I can tell my friends and family about and show to our children and someday grandchildren.

It was unintentional, but I learned that by joining Jordin's 365-day project, I had spent an entire year documenting and telling the story of us and our married life. This is that story.

These are the daily drawings of Us.

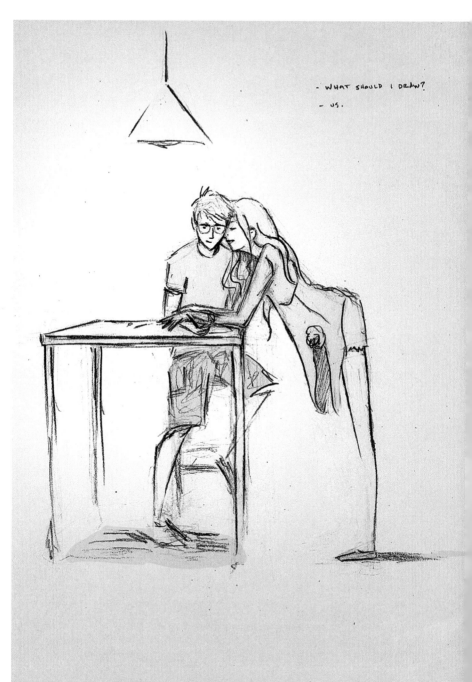

- WHAT SHOULD I DRAW?
- US.

Jordin,

"Us" is the "we," made up of you and me.

Forever we will be, as one you and me,
Burning bright, like a star, for eternity.

I love you forever,
Curtis

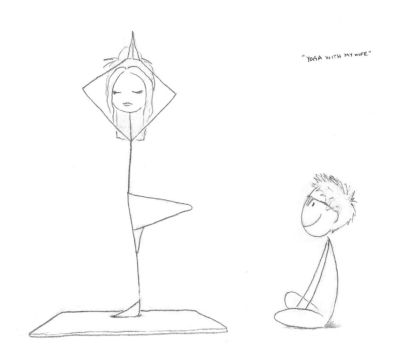

"YOGA WITH MY WIFE"

My new favorite hobby of my wife's.

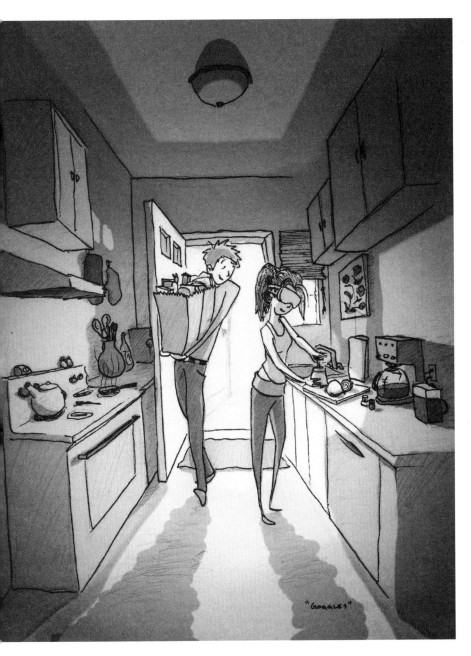

Snowboard goggles and onions.

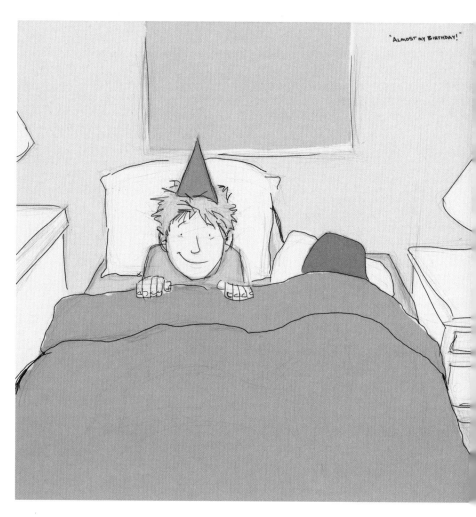

Almost my birthday!

"To be painted..."

A perfect birthday. I think I'll finish and paint this one tomorrow.

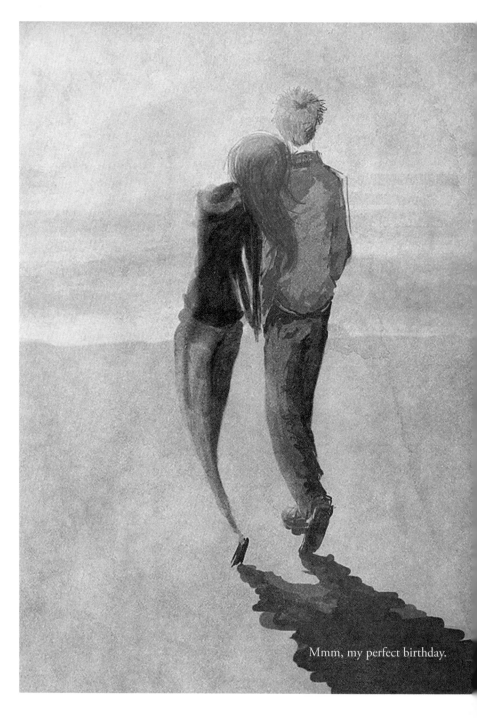

Mmm, my perfect birthday.

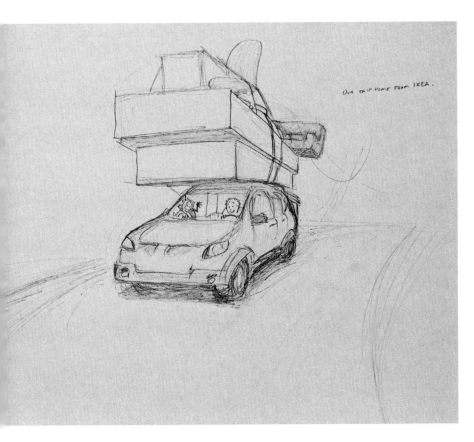

Our trip home from IKEA.

Dumb fight.

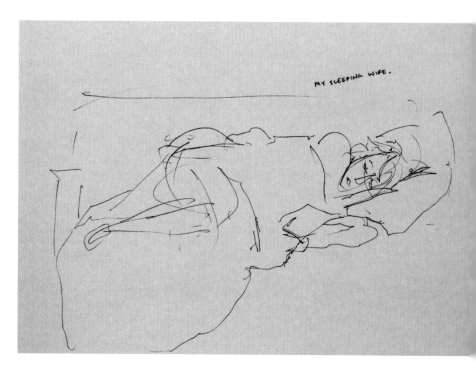

My sleeping wife.

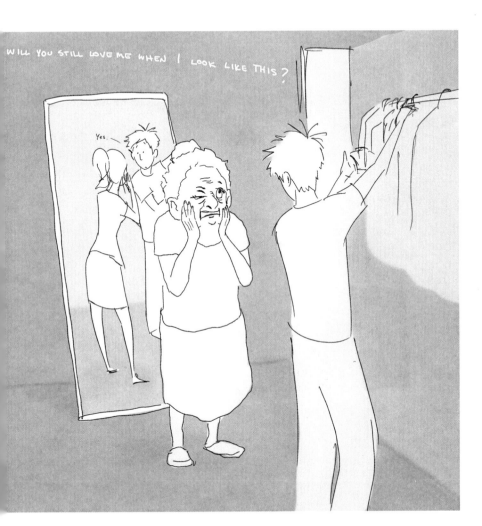

Will you still love me when I look like this?

My sleepy girl.

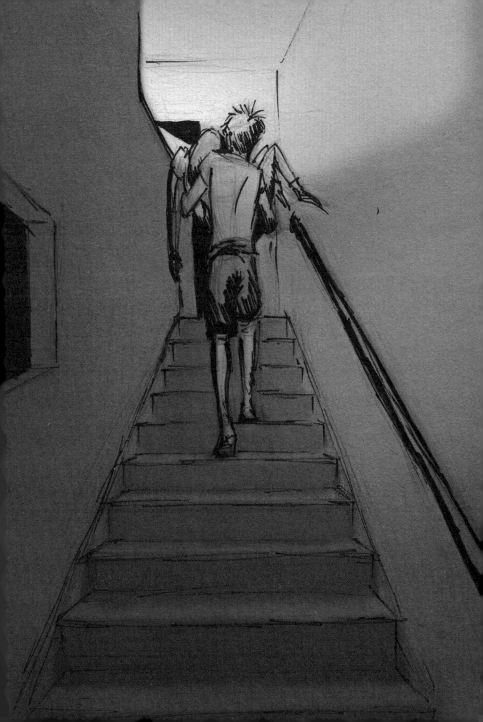

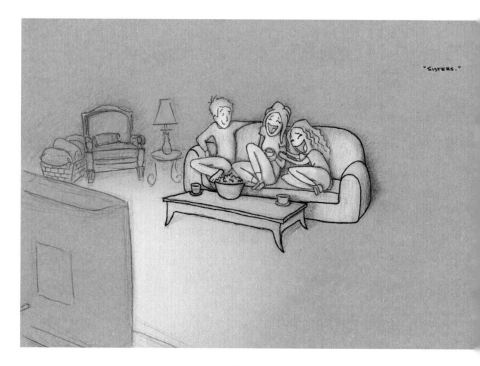

Sisters.

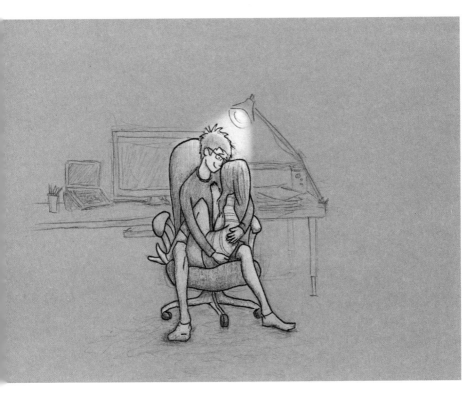

My wife watched the season finale of *Castle* today. Those who watch it understand.

Happy anniversary,
love of my life!

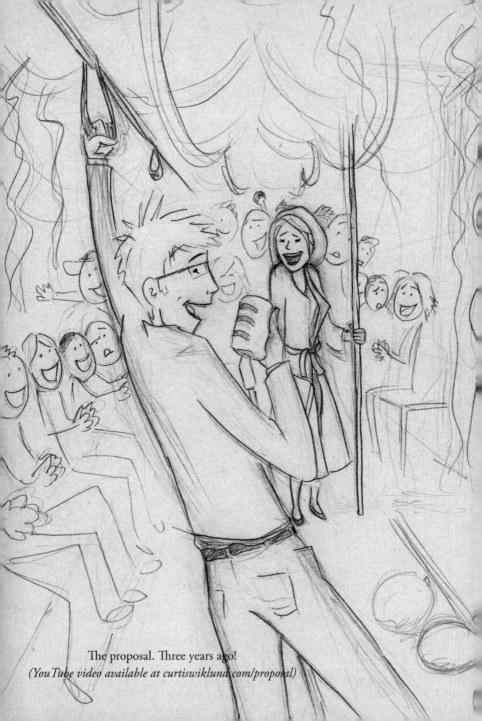

The proposal. Three years ago!
(YouTube video available at curtiswiklund.com/proposal)

Sometimes one phone call can totally change your plans.
(The University of Michigan called me today to offer a full-ride
scholarship and a paid staff position to get my master's. I am shocked and
ecstatic. I love school, and I love learning. I am going back to school!)

Dog-sitting.

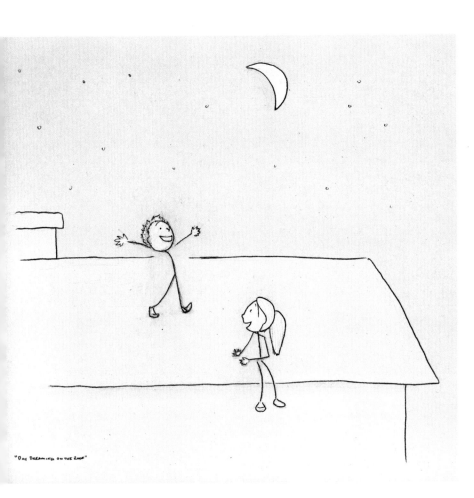

Daydreaming on the roof.

Back-scratching as a sedative.

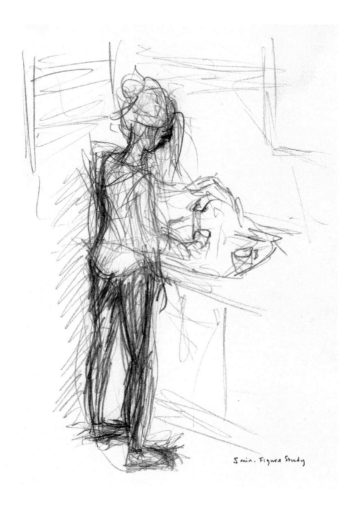

"Dishes." Five-minute figure study.

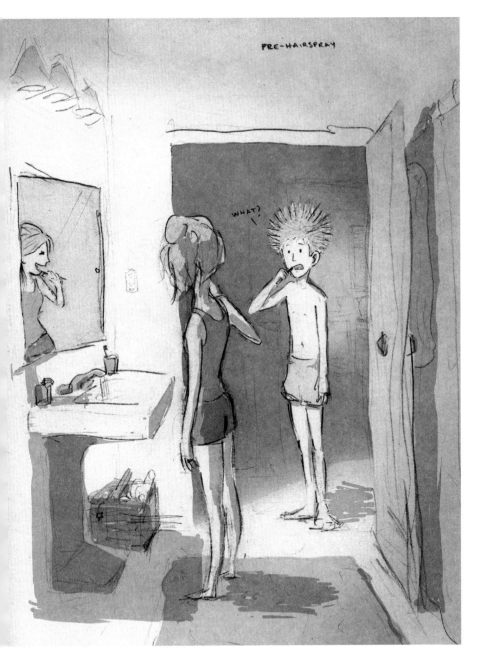

Post-shower, pre-hairspray.

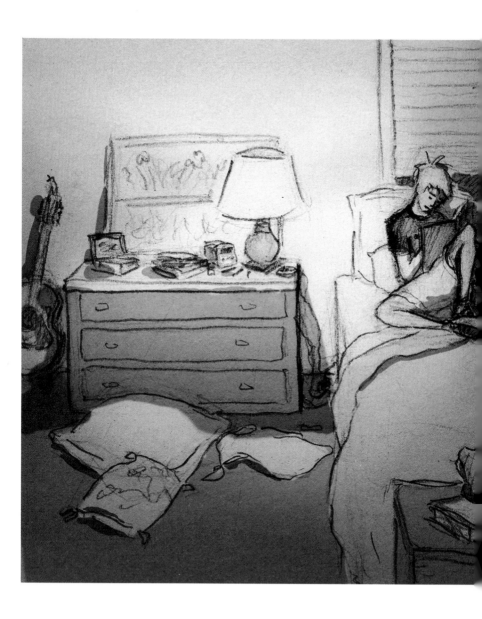

Drawing in bed.

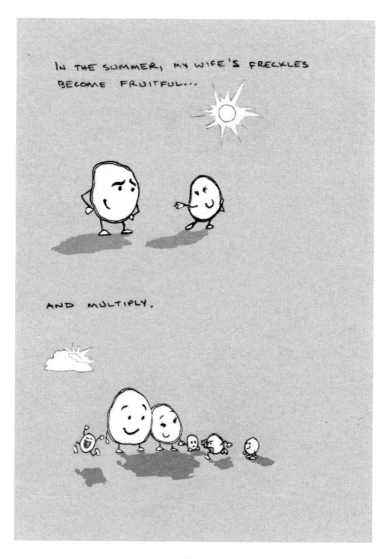

In the summer, my wife's freckles become fruitful and multiply.

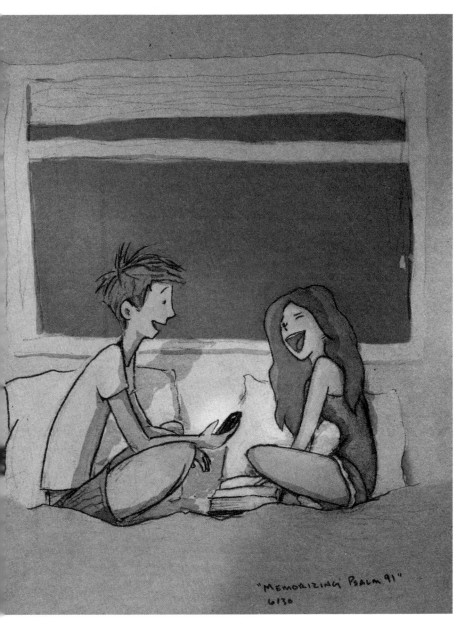

Memorizing Psalm 91.

"Those who live in the shelter of the Most High will find rest in the shadow of the Almighty . . ."

Tag in the park.

Sometimes, I think my wife thinks I look like Mr. Darcy.

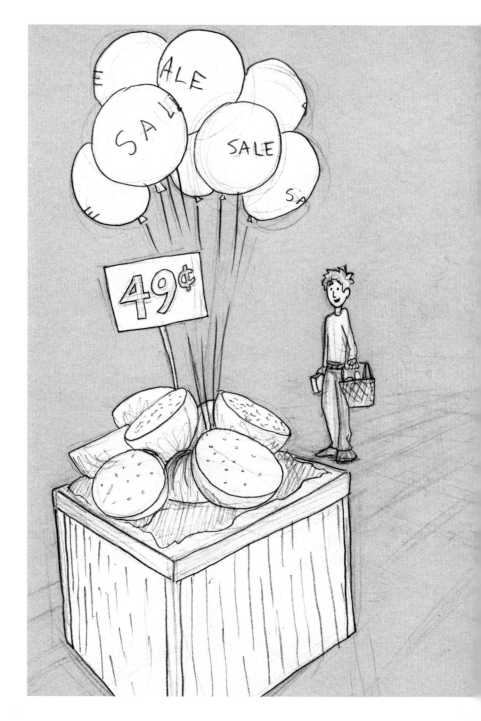

Me: Babe, stay in the car and take a nap. I'll take care of groceries for tonight.
Wife: *smile*

In the store . . .
Me: Whoa, 49 cents for half a watermelon? What a deal! I'll grab two!

At home . . .
Wife: Thanks for getting watermelon!
Me: No problem—they were 49 cents!
Wife: Per pound?
Me: Ooooh . . .

I've concluded the following: I'm best when my wife is with me.
(Not to mention the fact that the grocery quest for five items somehow took me
literally an hour. It would have taken her five minutes.)

My wife keeps me company when I need to pull a late-nighter.

Hard night.

There is one mosquito in the house. Even though I don't know
where he is, he knows exactly where I am.

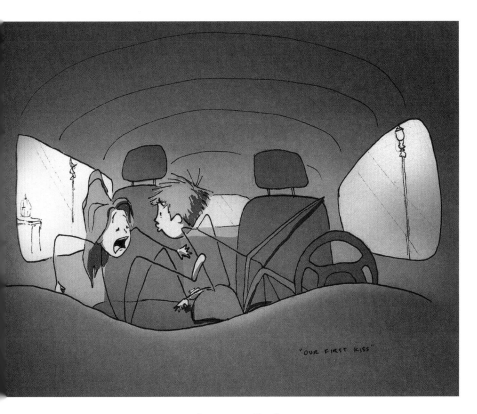

Remembering our first kiss.

I STILL LEARN SOMETHING NEW ABOUT MY WIFE EVERY DAY. SHE IS A PROFESSIONAL PAINTER. 7/20

I still learn something new about my wife every day. She is a professional painter.

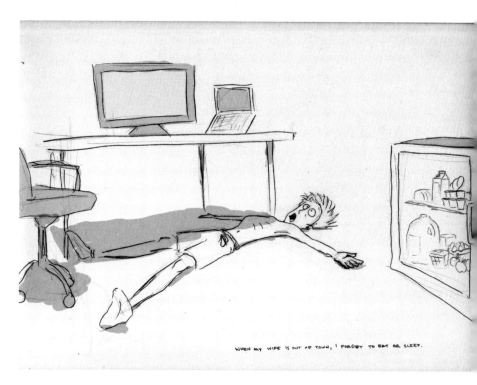

When my wife is out of town, I forget to eat or sleep.

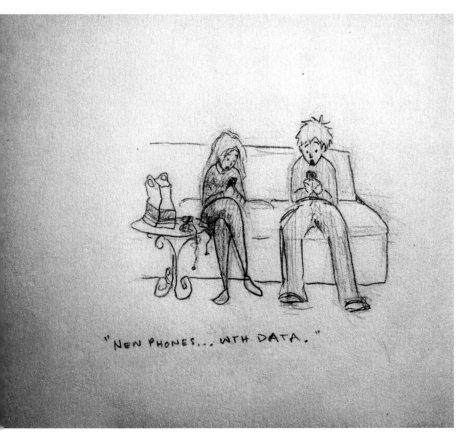

New phones . . . with data.

Sister-in-law trying to explain the ending of
Harry Potter and the Deathly Hollows, Part Two.

5min

Five-minute warm-up sketch.

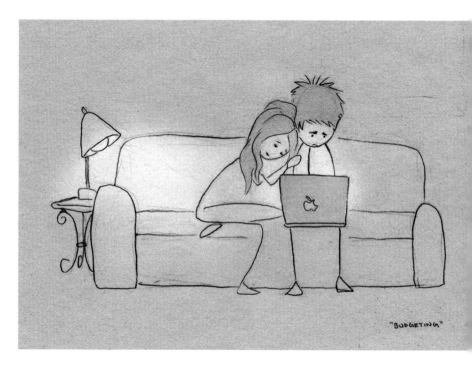

Budgeting.

My wife's pancake memories.

I am a night owl. My wife is not. I've been trying to change, but then I started doing these daily drawings.

"NIGHT OWL."

Kissing on the beach.

The places I find my wife's hair clip.

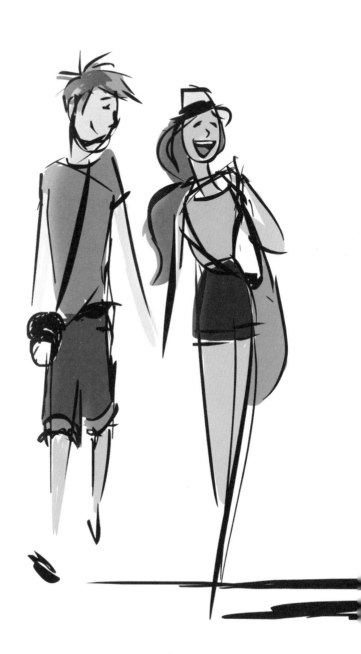

I don't want summer to end.

I DON'T WANT SUMMER TO END

Late-night editing.

It's a very busy time of year for us.

While I work.

"Out Cold."

Out cold.

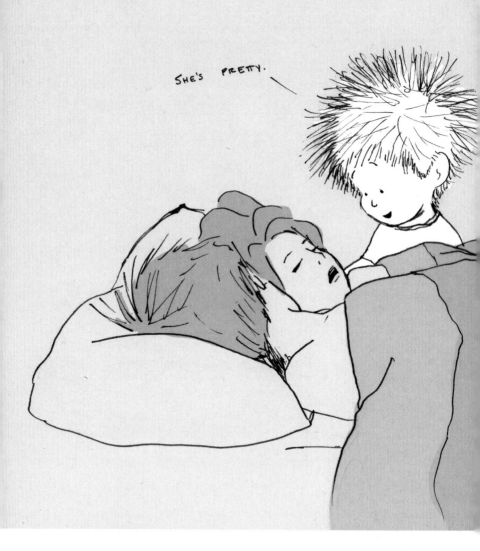

My wife asks me this every once in a while. I like thinking about it. What would your six-year-old self say if he could see you today?

SO ARE YOU AN ANIMATOR AT DISNEY ON THE SIDE THEN?

What would your six-year-old self say if he could see you today?
"So are you an animator at Disney on the side then?"

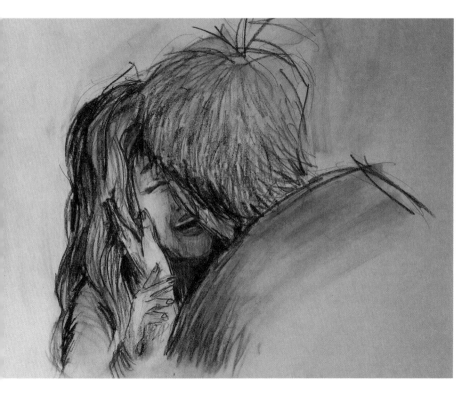

Getting messy with charcoal. Did a lot of laughing today.

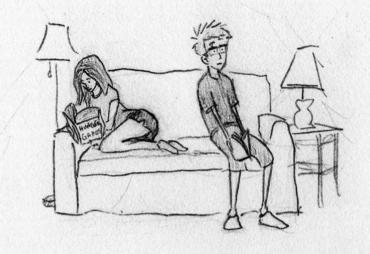

In the last 48 hours of our vacation, my wife has read over 900 pages of her new favorite series. I pretend to read too, but every other sentence seems to spark a new idea and I begin thinking or daydreaming. After 48 hours, I've read a total of 12 pages from my 120-page book.

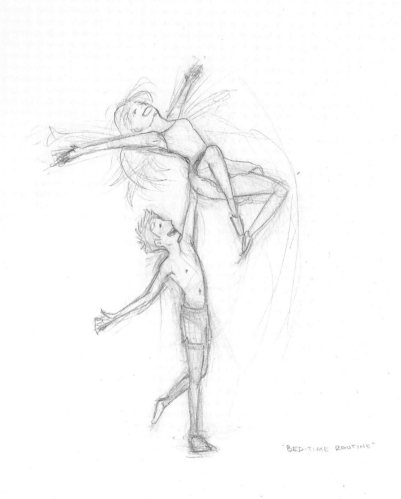

"BED-TIME ROUTINE"

We watched *Mao's Last Dancer* tonight. Feeling inspired, I'm pretty sure this is what we looked like before bed.

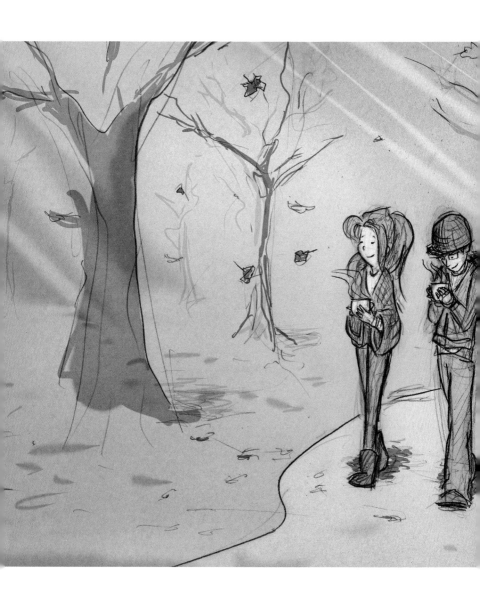

Mmmm, wearing layers.

Budgeting, Part 2.

Driving to Cedar Point with a bus full of high-schoolers.
We should've gotten more sleep last night.

Guitar break.

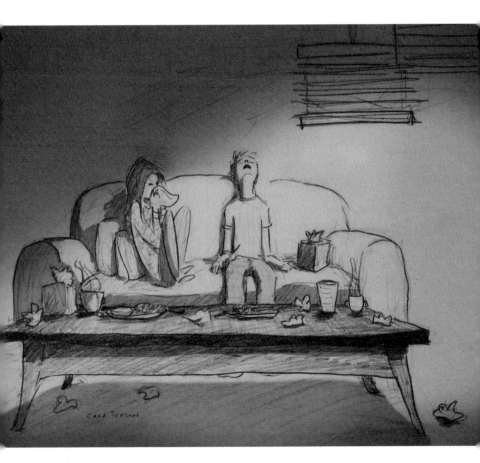

Cold season.

Cider Mill.

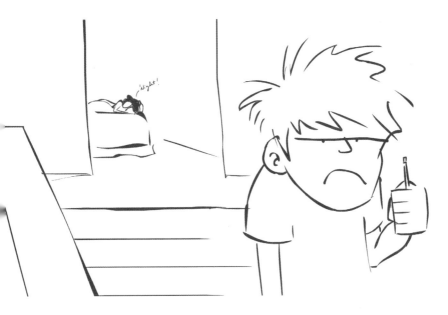

Sometimes, I don't feel like drawing at all.

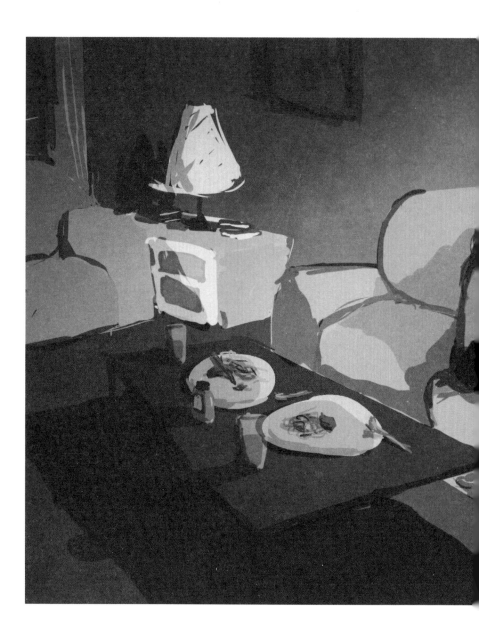

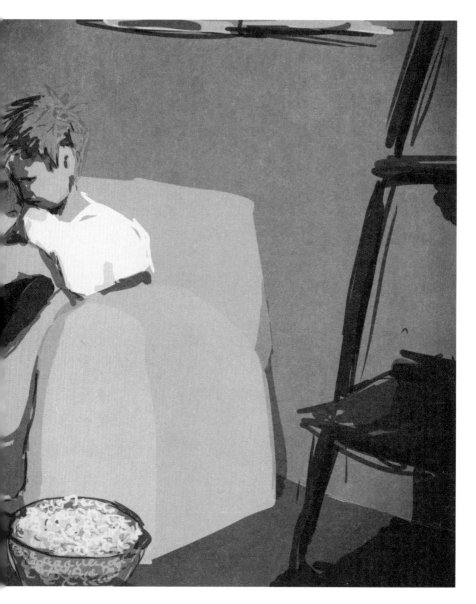

Home is safe.

Light at the end of the tunnel.
Ours is December 25th!

I wonder what my younger self would have thought if someone told me the girl on my tee-ball team would be my wife.

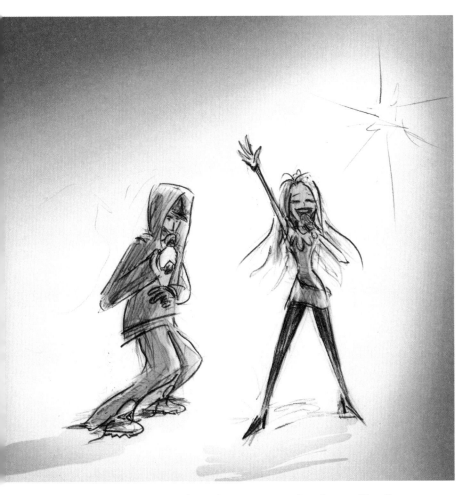

Christmas at our church. I performed as Eminem and Jordin was Katy Perry.

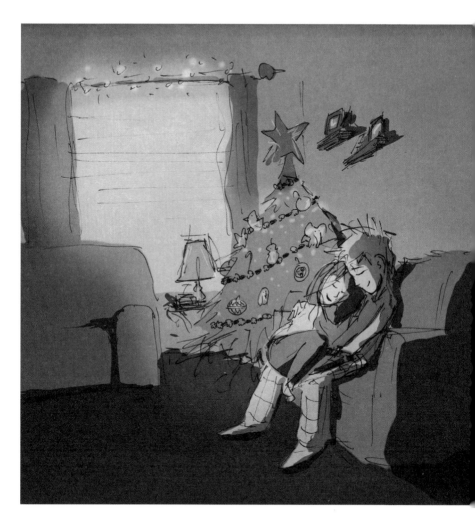

Our Christmas tree.

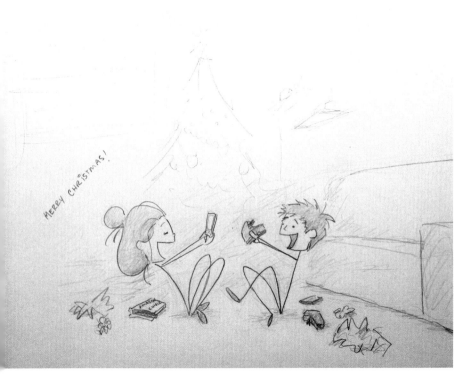

Merry Christmas!

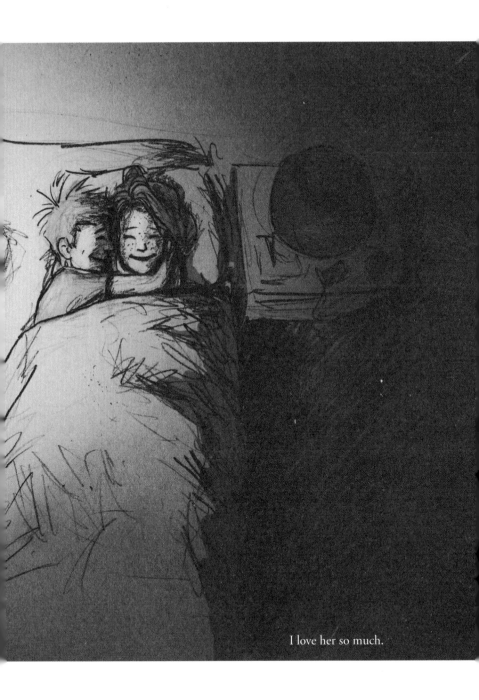

I love her so much.

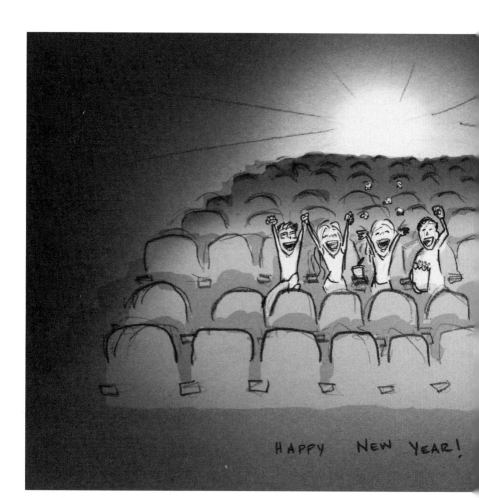

HAPPY NEW YEAR!

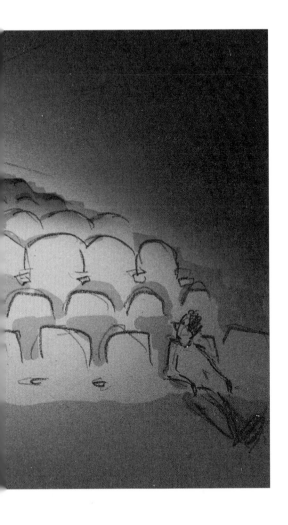

Happy New Year, from those who know how to party to the countdown in an empty movie theater!

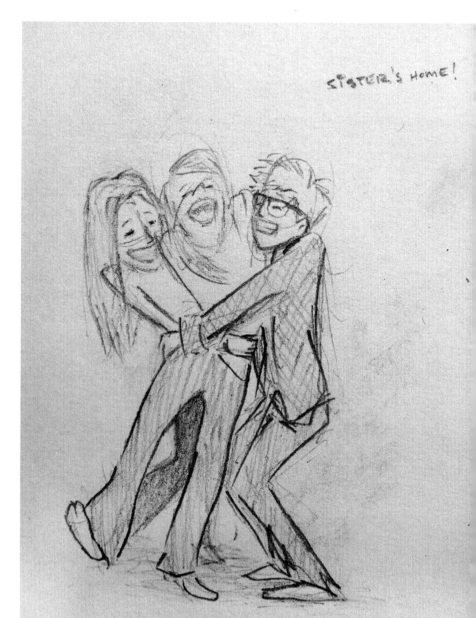

Lil' sis is home!

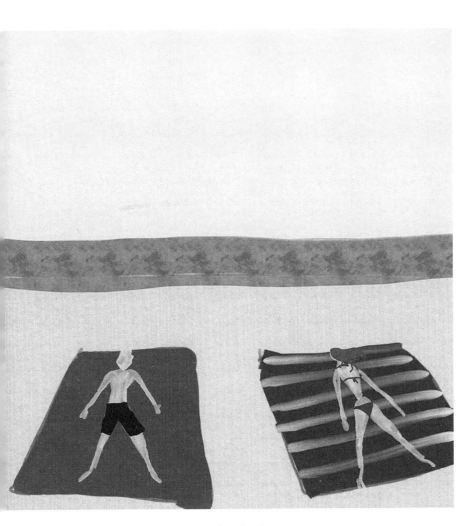

Leaving for Florida!

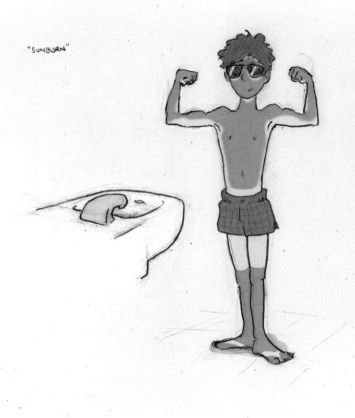

Sunburn.

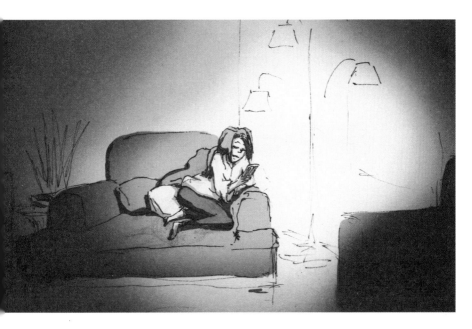

A thousand books in one device. My wife is in heaven.

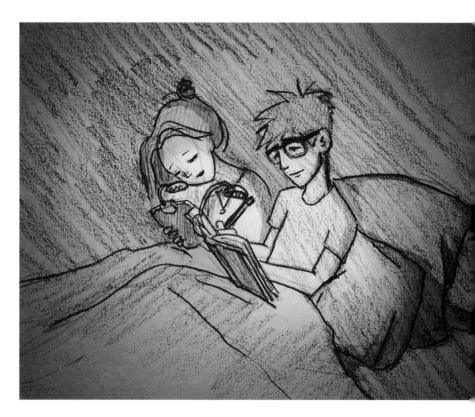

Nighttime routine.

Last night, my wife had a dream of what our first baby would look like.
I played the police sketch artist and drew her mug shot
before she lost the image from her mind.
Dark eyes and dark hair, where's that going to come from?! (She's holding a sippy cup.)

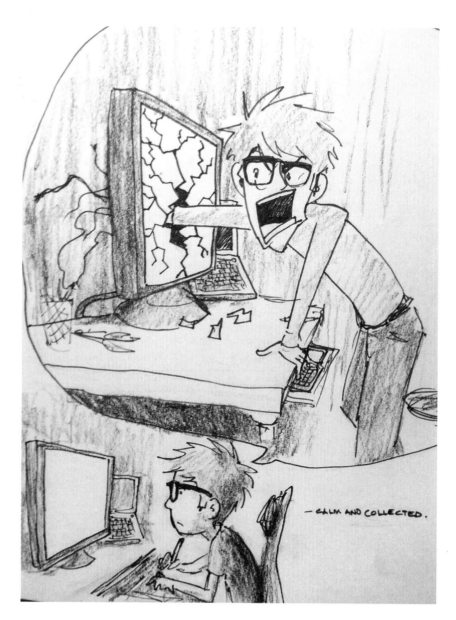

Calm and collected.

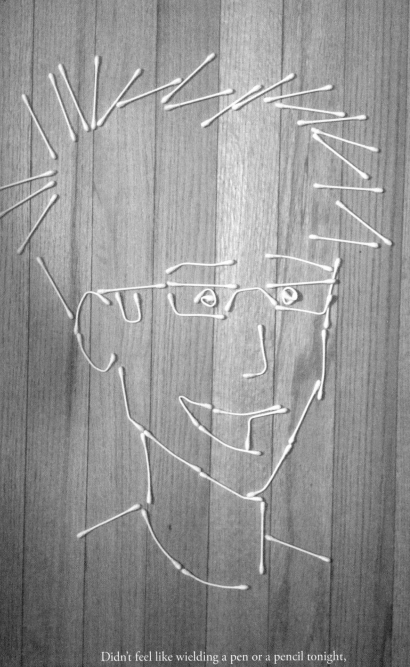

Didn't feel like wielding a pen or a pencil tonight,
so I made a self-portrait out of Q-tips.

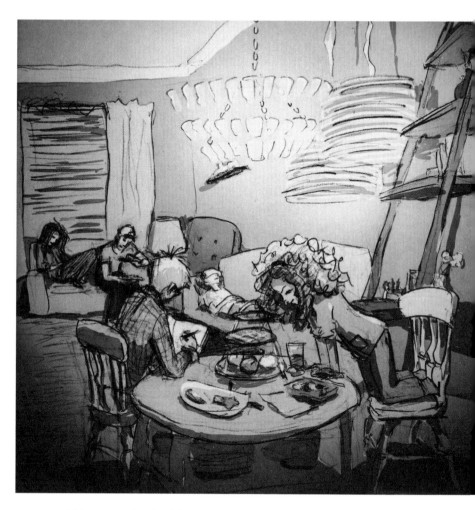

Siblings over for the following activities: Sculpey clay, dinner, and the flu.

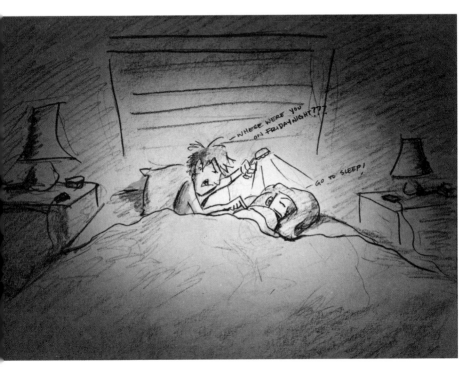

New reading lamp works well as an interrogation light.

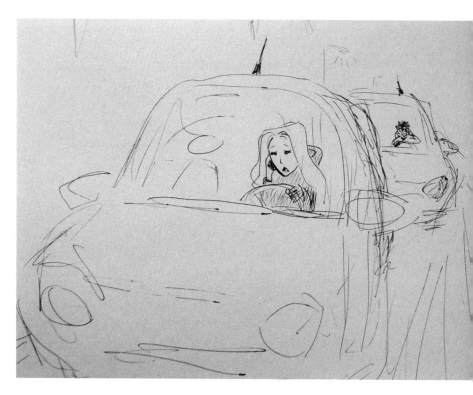

Staying awake on the way home.

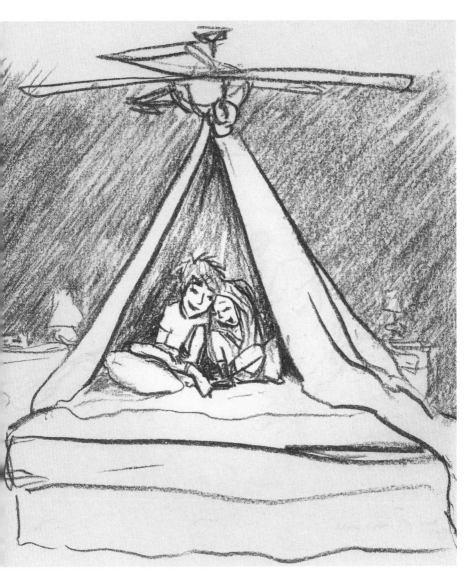

Sleepover with my best friend.

Some place I'd like to be.

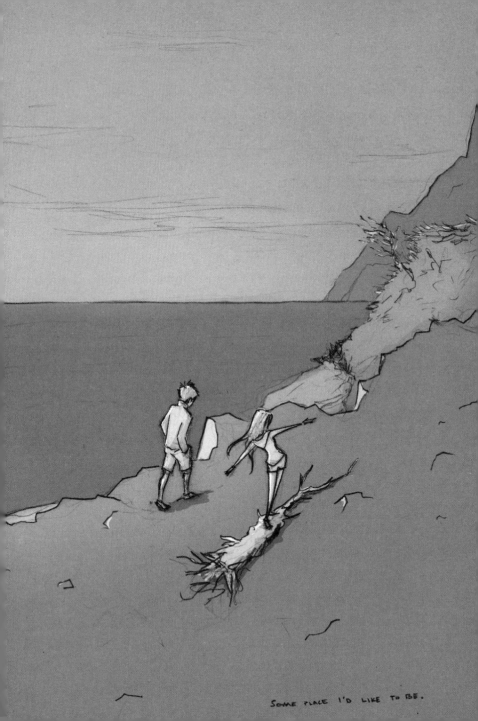

SOME PLACE I'D LIKE TO BE.

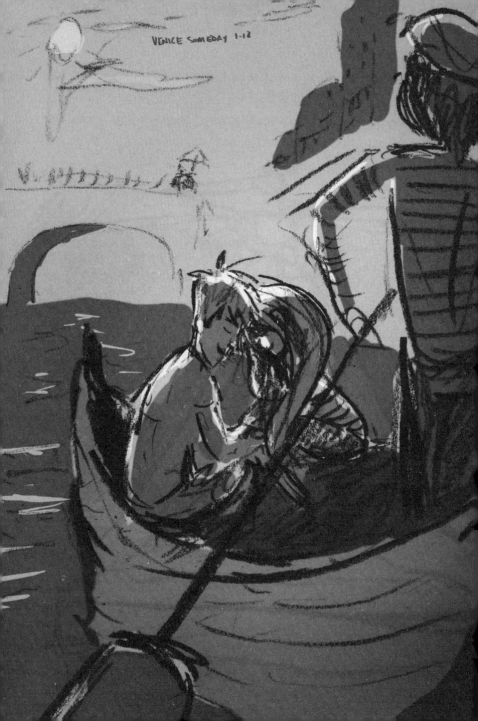

Evening in Venice, someday.

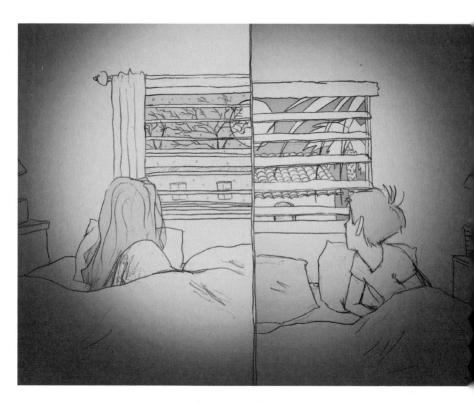

Same moon, far apart.

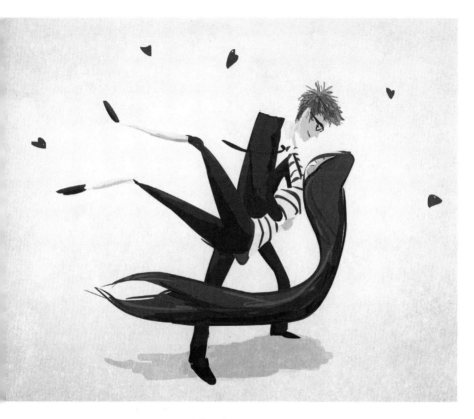

My valentine.

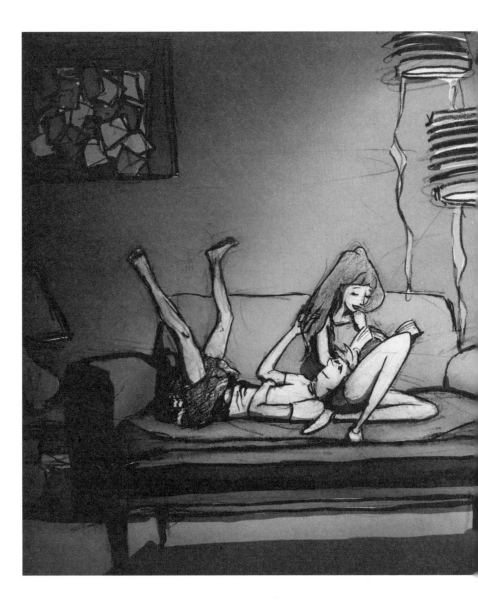

Tonight, my wife and I had a long list of things to get done. Instead, we sat on the couch, she read to me, I played guitar for a while, and then I drew a picture. In my opinion, these were all better alternatives to "the list." And I like to let my feet float up in the air while lying on the couch. Don't know why. Sometimes I do it with my hands, too.

Almost finished with a year of drawing.

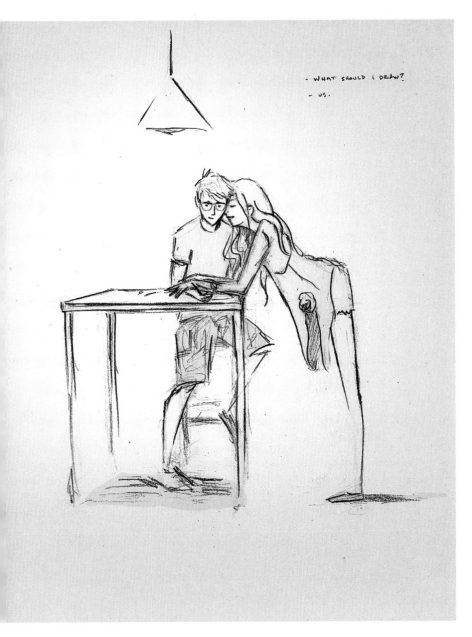

What should I draw?

Us.

We're pregnant! I have a feeling the drawings will be changing soon.

WE'RE PREGNANT :)

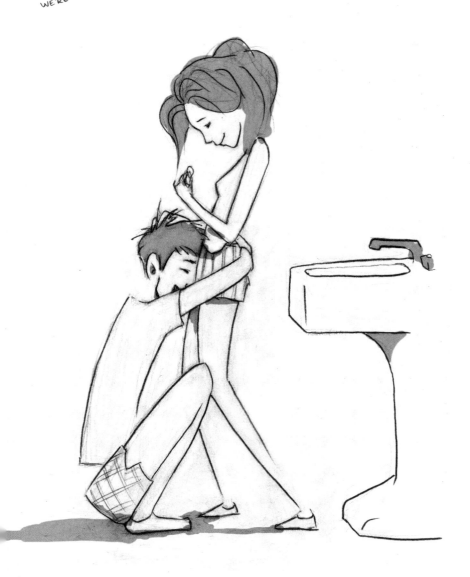

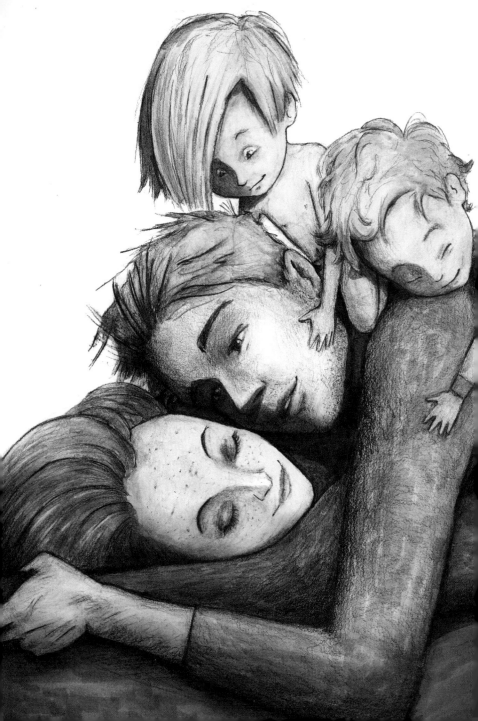

About the Author:

Curtis Wiklund lives in Michigan with his wife, Jordin, and their two little boys. They own a wedding photography business and travel together to document couples who are in love. Curtis continues to draw and enjoys capturing the magic in ordinary moments of his life with Jordin and their boys. You can follow their story and see more of Curtis's work on social media and his website.

Instagram: @curtiswiklund
Facebook: @curtiswiklunddrawings
Website: www.curtiswiklund.com

Andrews McMeel Publishing
a division of Andrews McMeel Universal
1130 Walnut Street, Kansas City, Missouri 64106

www.andrewsmcmeel.com

17 18 19 20 21 SDB 10 9 8 7 6 5 4 3 2 1

ISBN: 978-1-4494-8346-3

Library of Congress Control Number: 2017945542

Editor: Patty Rice
Designer/Art Director: Holly Swayne
Production Editor: Amy Strassner
Production Manager: Tamara Haus

ATTENTION: SCHOOLS AND BUSINESSES
Andrews McMeel books are available at quantity discounts with bulk purchase for educational, business, or sales promotional use. For information, please e-mail the Andrews McMeel Publishing Special Sales Department: specialsales@amuniversal.com.